# Beginner's Guide to MOSAICS

Mosaics are a snap to create—especially when your teacher is Heidi Borchers! Heidi has developed a simplified approach to the art form that will have you creating lovely tile and glass inlays. From small gift items to enchanting garden enhancements, there are designs to please everyone. Use an array of materials to transform a variety of surfaces with the time-honored skill of mosaic crafting—made easy!

# Contents

LEISURE ARTS, INC.
Little Rock, Arkansas

# Meet Heidi Borchers

For Heidi Borchers, creativity isn't just a hobby, it's a way of life. The prolific designer is the daughter of Aleene Jackson, the inventor of Aleene's Tacky Glue. As a child, Heidi spent a great deal of time in her mother's California retail store where she attended numerous classes on "gluing, gluing, and more gluing."

During her teen years, Heidi added sewing, tailoring, dressmaking, and art to her inventory of creative skills. To complement these, her college studies included marketing and merchandising. By the age of 18, Heidi took over the management of her mother's store. Over the next two years, Heidi apprenticed with top designers, eventually developing her own style of craft and floral design. She also became a popular demonstrator at the local county fair and various women's club events.

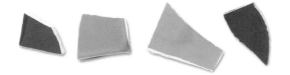

Looking back at those early days, Heidi says, "My mother was one of the pioneers of the crafting industry, one of the first women who brought crafts into the Hobby Industry Association," says Heidi. "There were specialty shops in those days, but people today don't realize that there wasn't a true craft shop until 1968. We're currently trying to convince the Craft and Hobby Association to establish a museum to capture the history of the crafting industry."

In 1969, Heidi was a busy mom herself when she opened Craft Source, her own retail/wholesale business which she operated for twenty years. Heidi's first of many hard-bound books was published in 1983, followed by an impressive series of designs for national magazines. In 1986, she made her national cable debut as co-host of her mother's show, *Aleene's Creative Living*.

Today, Heidi and her daughter, Starr, run a teaching studio called "A Creative Spark" in Cambria, California. Heidi resides in Cambria with her husband, Harold, and their dog, Jupiter. Heidi has three grown children, three stepchildren, and ten grandchildren. In addition to spending time with family, Heidi stays as busy as ever with her design projects, and she encourages others to discover that being creative isn't difficult.

Says Heidi, "A lot of times, projects like mosaics tend to look like they're hard, but they're not hard at all. I think you just need the basics provided for you. That's what I've done, showing a simplified way to do mosaics. Having my studio has helped me to develop this technique and through the studio I've already proven to so many people that they can do it. I truly believe that everyone is creative."

# Supplies

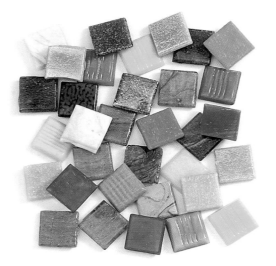

1" sq. Glass Tiles

Glass Squiggles

1" sq. Chunky Glass Tiles

Small Tumbled Stained Glass Pieces

1¹/₄" sq. Glass Tiles

Large Tumbled Stained Glass Pieces

Tumbled Mirror Pieces

Small Flat Translucent Marbles

Ceramic and Glass Beads

Small Flat Opaque Marbles

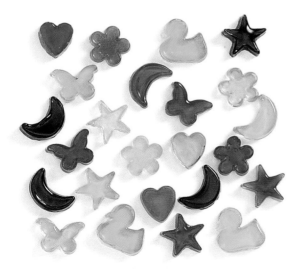

Glass Shapes

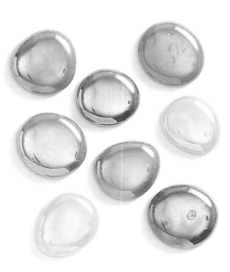

Large Flat Opaque Marbles

# China & Ceramic Pieces

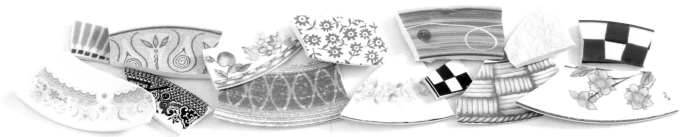

Broken Plates/China

Vintage Reproduction Ceramic Tile Pieces

Solid Ceramic Tile Pieces

Patterned Ceramic Tile Pieces

Ceramic Pottery Pieces

Ceramic Flowers and Leaves

Ceramic Hearts

Ceramic Geometric Shapes

Ceramic Circles and Rectangles

$1/2$" sq. Ceramic Tiles

1" sq. Ceramic Tiles

$1 1/4$" sq. Ceramic Tiles

# Tools & Materials

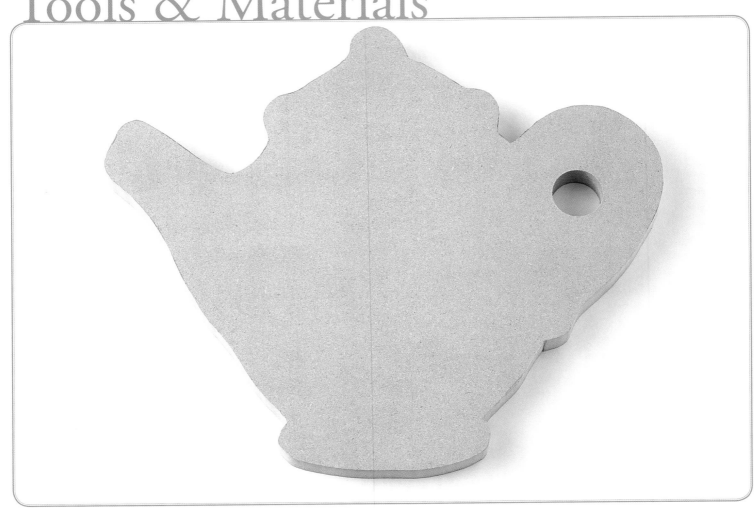

MDF Wood Base

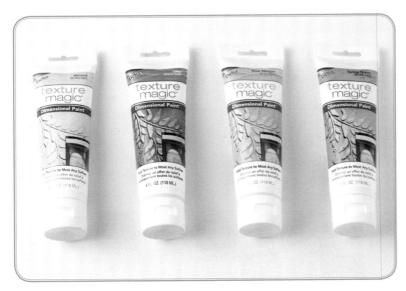

Delta Texture Magic™ Dimensional Paint™
(Used in Heidi's Faux Mosaic Technique)

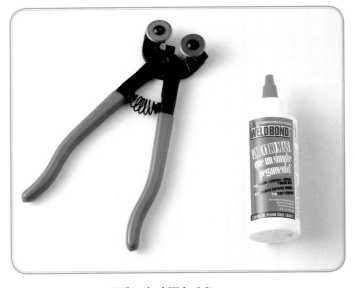

Wheeled Tile Nippers
Weldbond® Universal Adhesive

# Arranging Mosaic Pieces

## DO:

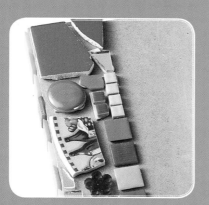

Leave a small space between mosaic pieces for the grout.

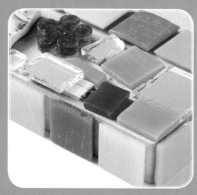

Place mosaic pieces around the sides of the base if desired.

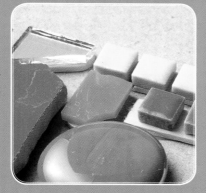

Glue part of a craft stick under any thin mosaic pieces to lift them up.

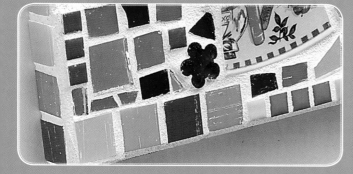

## DON'T:

Leave excess space between mosaic pieces for the grout.

Use so much glue that it shows around the pieces.

Glue the mosaic pieces too close together if they will be grouted.

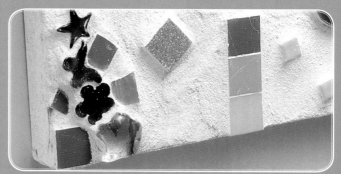

# *Heidi's* Basic Mosaic Technique

*Follow these simple steps to cut and adhere mosaic pieces and to apply grout—all in one day. Use this technique to make the projects on pages 12 to 27. Always wear goggles when cutting mosaic pieces. For mosaic projects with wooden bases that will be used outdoors, spray the entire wood piece with primer and allow it to dry before beginning the project. Use spray primer in a well-ventilated area.*

 Cover the work area with several layers of kraft paper.

 For projects with a pattern, trace the pattern onto tracing paper; cut it out. Draw around the pattern onto the base.

Choose mosaic pieces in the desired colors for the project. Use the materials listed with the individual projects, or feel free to substitute other types of tile, glass, or ceramic pieces. Some projects call for Smalti tiles (hand-cut opaque glass tiles that vary in color and shape), but other glass tiles may be used in their place.

 Follow Arranging Mosaic Pieces, page 9, to place the mosaic pieces on the base, using wheeled tile nippers to cut the pieces as needed.

 When all the pieces are in place, pick up one at a time (use tweezers to pick up small pieces), place a small drop of Weldbond® Universal Adhesive on the back of the piece, and glue it to the base. Mosaic the sides of the base as desired. Allow the glue to dry (about one hour).

## *Heidi's Hints:*

- Turn accidentally broken pottery and dishes into fabulous mosaics.

- Wheeled tile nippers make it easy to cut the desired shape from tiles, mirrors, stained glass, and china pieces.

- For additional bonding and waterproofing when mixing grout, Weldbond® Universal Adhesive may be added to the water, using 2 parts glue and 1 part water. Stir the mixture into the dry grout, adding more water as needed to achieve a paste-like consistency.

- Use caution if you smooth the grout with your fingers; the cut edges of the mosaic pieces can cut through disposable gloves.

**6** Begin grouting when the pieces are set. Wearing gloves, pour grout into a plastic container. Slowly add water and mix thoroughly with a craft stick to form a thick, smooth paste; then, use the stick and work quickly to apply the grout between the mosaic pieces, filling in the spaces.

**7** When the project is grouted, begin at the top and wipe a slightly damp sponge over a small area, just uncovering the mosaic pieces and smoothing out the grout. Don't wipe the pieces too much, but leave a grout haze on them.

**8** Allow the haze to air dry or use the hairdryer on low for several minutes until the haze is dry and looks chalky. Being careful to avoid the damp grout between the pieces, use a dry paper towel to clean each mosaic piece separately. Use a cotton swab for any detailed cleaning. Let the grout dry overnight. Use vinegar on a swab or paper towel to remove any remaining haze.

**9** For outdoor pieces, follow manufacturer's instructions to seal the grout after 3-4 days. Use paper towels to remove any sealer from the mosaic pieces. Allow the sealer to dry.

## BASIC MOSAIC SUPPLIES

*Lists of specific materials accompany individual project information. Many of the wood bases, tools, mosaic pieces, and other materials listed are available through www.heidiborchers.com, at local craft or hardware stores, or online. Follow manufacturer's instructions to use each product.*

Project base (see project materials)
Spray primer (for outdoor wood-based projects)
Kraft paper
Tracing paper
Goggles
Wheeled tile nippers
Mosaic pieces (ceramic and glass tiles, mirrors, stained glass, china, flat marbles, beads, and ceramic shapes)
Tweezers
Weldbond® Universal Adhesive (used to attach mosaic pieces and may be used as a grout additive/bonding agent)
Disposable gloves
Sanded grout (see project materials for color)
Plastic containers
Craft stick or 1$^{1}$/$_{2}$"w plastic putty knife to apply grout
Household sponge
Hairdryer (optional)
Paper towels
Cotton swabs
White vinegar
Long-lasting grout sealer with brush (for outdoor projects)

# Mosaic Cubes

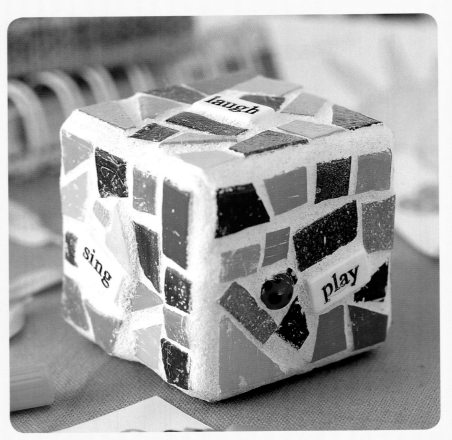

### MATERIALS FOR PLAY CUBE
Basic Mosaic Supplies, page 11
2" wood cube
Mosaic pieces:
    Glass tile pieces
    Assorted word beads
    Ladybug glass beads
White sanded grout

### MATERIALS FOR LOVE CUBE
Basic Mosaic Supplies, page 11
2" wood cube
Mosaic pieces:
    Broken plates/china
    1/2" sq. ceramic tiles
    Letter beads – LOVE
Alabaster sanded grout

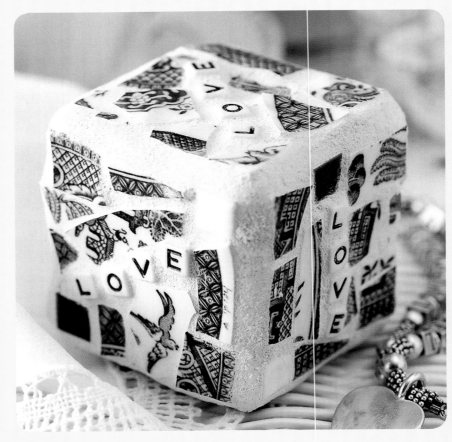

# Dream Your Passion Mirror

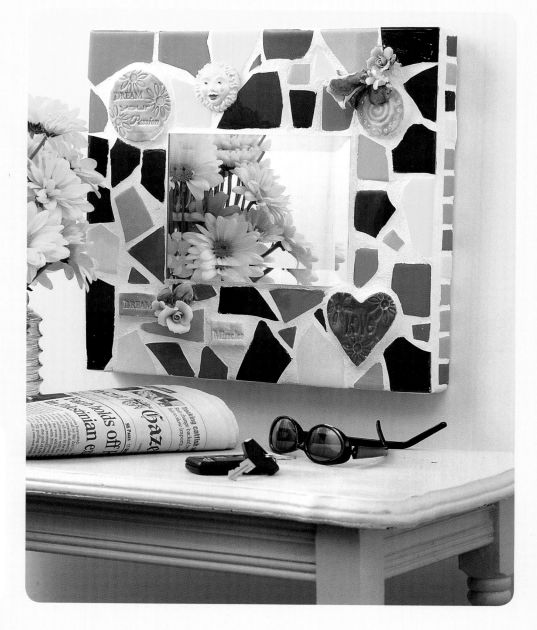

## MATERIALS

Basic Mosaic Supplies, page 11
12" x 13$\frac{1}{2}$" wood plaque with attached hanger
Mosaic pieces:
  5" x 7" beveled mirror
  Ceramic tile pieces
  1" sq. ceramic tiles – for sides
  Imprinted ceramic tiles – imprinted with
    Dream Your Passion, a spiral, Dream,
    Miracles, Love, and floral rubber stamps

Ceramic sunburst – to be glued to the mosaic
  after cleanup
Porcelain roses – to be glued to the mosaic
  after cleanup
White sanded grout

# Cinder Block Planter

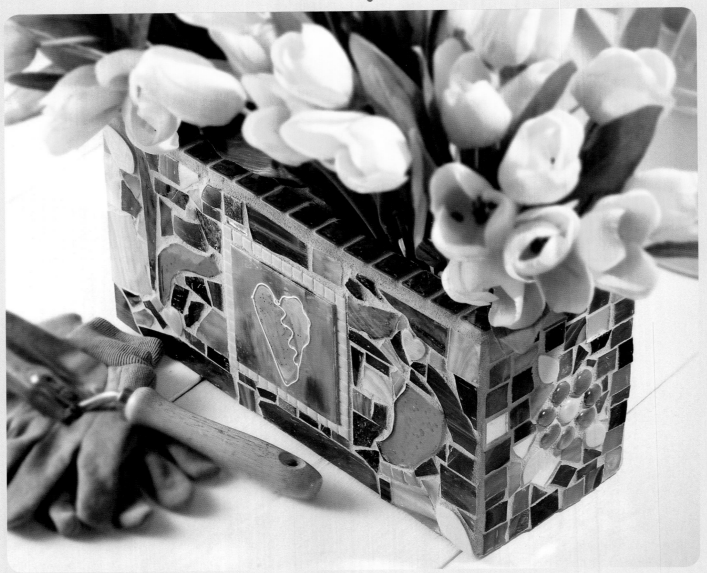

## MATERIALS

Basic Mosaic Supplies, page 11
8"h x 16"w x 6"d cement cinder block
4" x 4" ceramic decorative tile – heart
Mosaic pieces:
    $1^{1}/_{4}$" sq. ceramic tiles – for the top edges
    $^{1}/_{4}$" sq. ceramic tiles – to border the
        4" x 4" tile

Assorted mosaic pieces:
    Large stained glass pieces
    Flat marbles
    Mirror pieces
    Ceramic shapes – hearts
        and leaves
Rose Beige sanded grout

### Heidi's Hint:
Large stained glass scrap pieces are available at stained glass art stores and are usually priced by the pound.

# Moon & Stars Stepping Stone

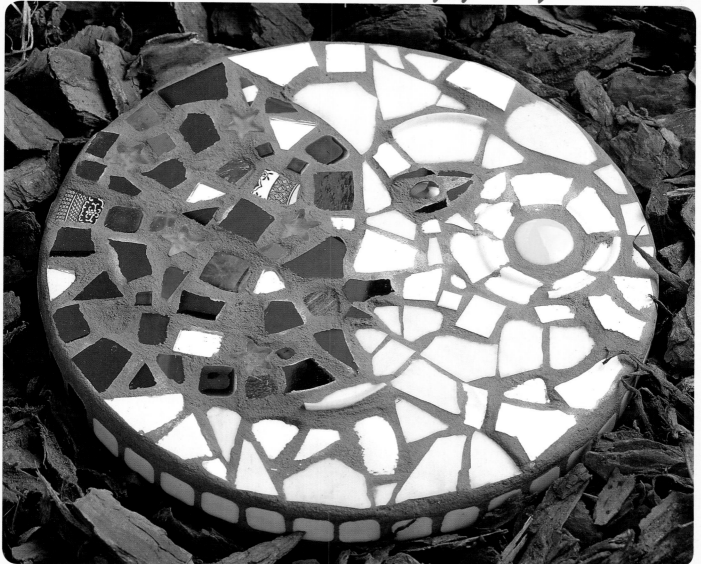

## MATERIALS

Basic Mosaic Supplies, page 11

12" dia. cement stepping stone with smooth, flat back
– work on the back side

Mosaic pieces:

Broken plates/china – white for moon and dark blue pattern for sky

Flat marbles – for eye and cheek

1" sq. ceramic tiles – white for side of moon and dark blue for sky and side of sky

Ceramic tile pieces – for eyelids and sky

1/2" sq. ceramic tiles – for sky

Mirror pieces – for sky

Glass shapes – yellow stars

Captain's Blue sanded grout

# Mosaic Tiles

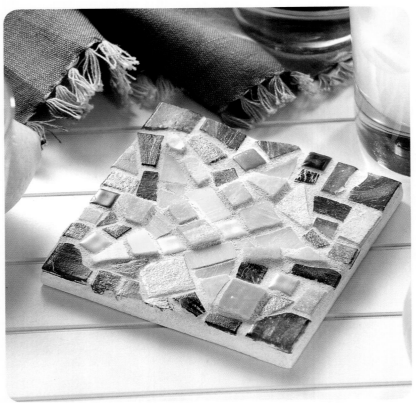

## MATERIALS FOR THE STAR TILE

Basic Mosaic Supplies, page 11
Pattern, page 39
4" x 4" ceramic tile for the base – work on the
    back side
Mosaic pieces:
    Glass tile pieces – yellow and blue
    Smalti glass tiles – yellow and blue
    $1/2$" sq. ceramic tiles – blue
White sanded grout

## MATERIALS FOR THE ROSE TILE

Basic Mosaic Supplies, page 11
Pattern, page 39
4" x 4" ceramic tile for the base – work on the
    back side
Mosaic pieces:
    Ceramic tile pieces – for the rose, stem,
      and leaves
    1" sq. ceramic tiles – gold flecked for the
      background
Concord Grape sanded grout

## MATERIALS FOR THE HEART TILE

Basic Mosaic Supplies, page 11
Pattern, page 39
6" x 6" ceramic tile for the base – work on the
    back side
Mosaic pieces for the heart:
    Ceramic tile pieces
Mosaic pieces for the background:
    Broken plates/china
    $1/2$" sq. ceramic tiles – red
    Smalti glass tiles – beige
North Sea Green sanded grout

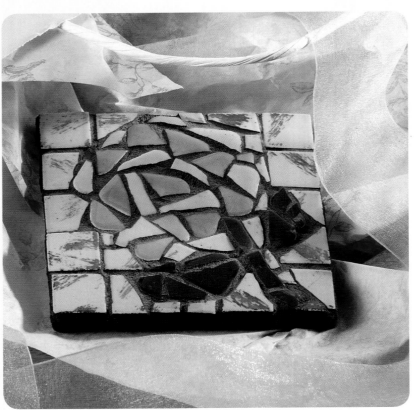

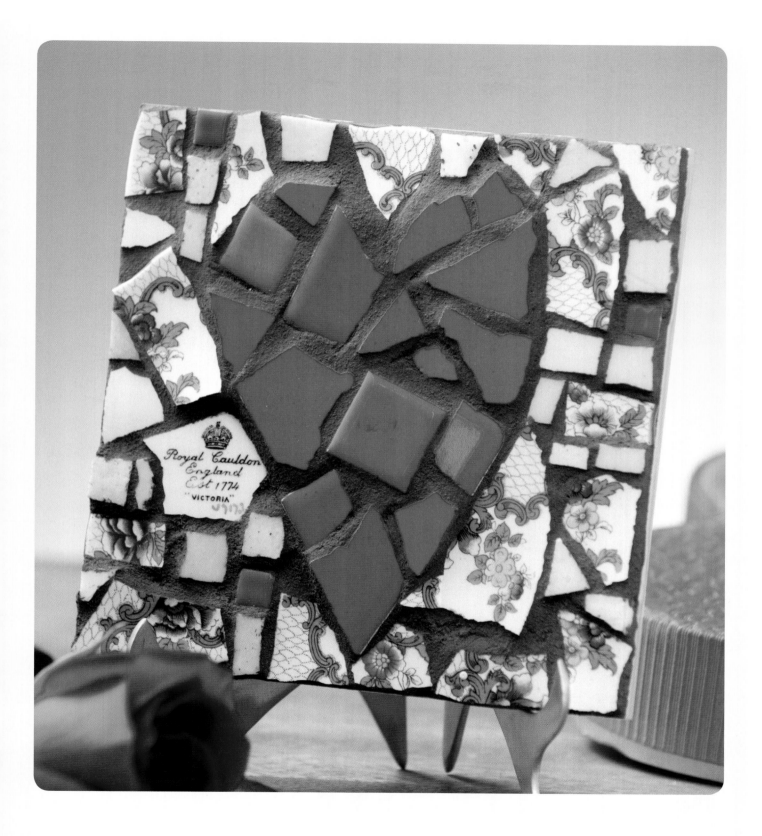

*Heidi's Hint:* Glue felt to the bottom of these decorative tiles to use them as coasters or trivets.

# Decorative Bricks

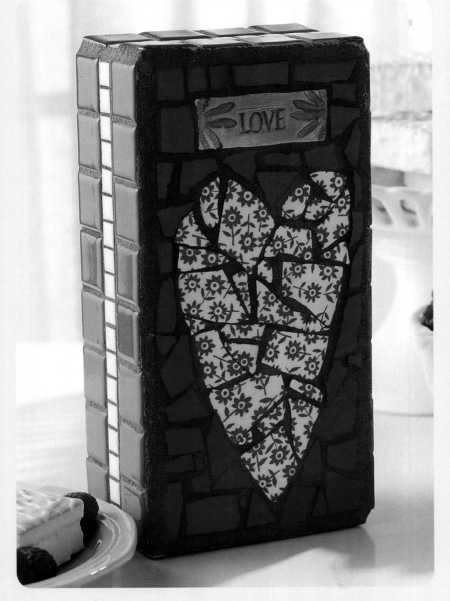

## MATERIALS FOR THE LOVE BRICK

Basic Mosaic Supplies, page 11
Pattern, page 41
2" x 4" x 8" brick paver
Mosaic pieces:
   Ceramic tile pieces – for background
   Broken plates/china – red and white
      floral for heart
   $1^{1}/_{4}$" sq. ceramic tiles – for sides
   $^{1}/_{2}$" sq. ceramic tiles – for sides
   Imprinted ceramic tile – imprinted
      with LOVE and floral rubber
      stamps
Pale Mauve sanded grout
Felt piece – for brick bottom

## MATERIALS FOR THE REFLECTIVE HEART BRICK

Basic Mosaic Supplies, page 11
Pattern, page 41
2" x 4" x 8" brick paver
Assorted mosaic pieces:
   Stained glass pieces – for heart
      and sides
   Mirror pieces – for background
Butter Cream Sanded Grout
Felt piece – for brick bottom

## Heidi's Hint:

Purchase an imprinted ceramic tile or make your own with polymer clay, a knife or cookie cutter, and rubber stamps.

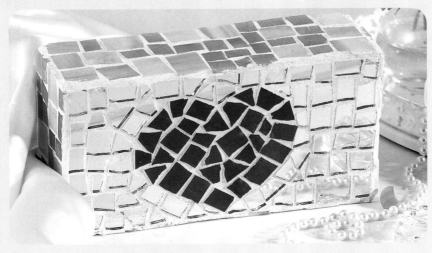

## MATERIALS FOR THE CAT BRICK

Basic Mosaic Supplies, page 11
Pattern, page 43
2" x 4" x 8" brick paver
Mosaic pieces:
  Stained glass pieces – for cat
  Two $\frac{1}{8}$" dia. glass beads –
    for eyes
  Letter beads – WELCOME
Assorted mosaic pieces:
  Mirror pieces
  $\frac{1}{2}$" sq. ceramic tiles
  1" sq. ceramic tiles
Platinum Grey sanded grout

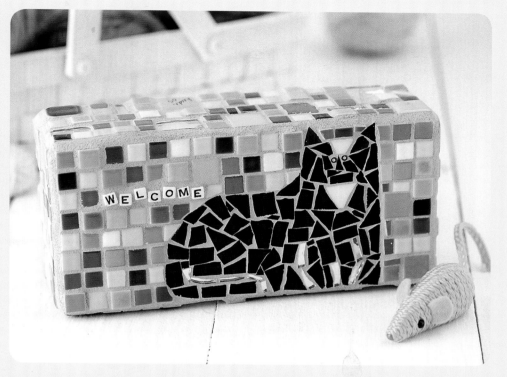

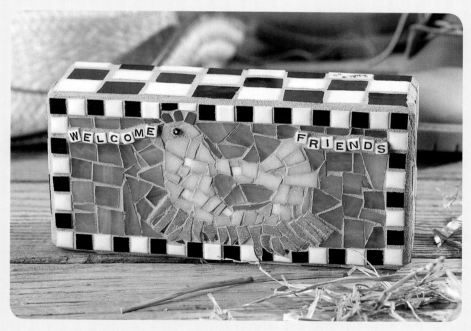

## MATERIALS FOR THE CHICKEN BRICK

Basic Mosaic Supplies, page 11
Pattern, page 42
2" x 4" x 8" brick paver
Mosaic pieces:
  Small stained glass pieces –
    for the background, wing,
    and spots on chicken
  Large stained glass pieces –
    for sides
  $\frac{1}{2}$" sq. ceramic tiles – for border
  Glass tile pieces – for chicken's
    body, beak, comb, and nest
  $\frac{1}{8}$" dia. glass bead – for eye
  Letter beads – WELCOME
    FRIENDS
Sahara Tan sanded grout

## SPECIAL INSTRUCTIONS

For the cat and the chicken, embed the eye beads
in the grout with the holes showing.

# Sunburst Plaque

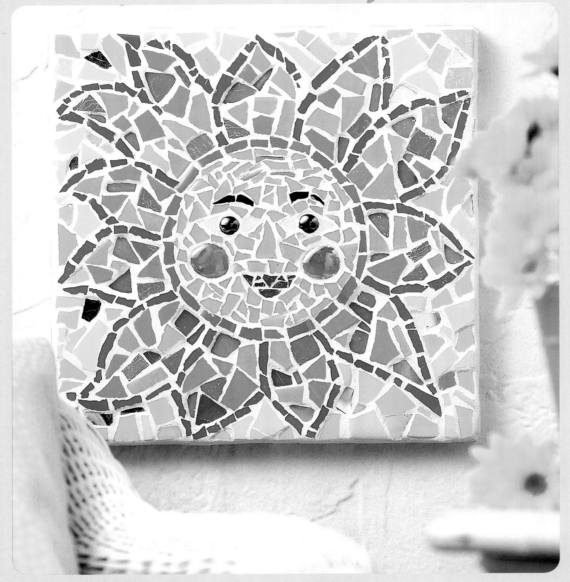

## MATERIALS

Basic Mosaic Supplies, page 11

Pattern, page 40 – enlarge the pattern to 165% on a photocopier

12" sq. MDF wood plaque

Mosaic pieces:
  2 opaque small flat marbles – for eyes
  2 opaque large flat marbles – for cheeks
  1" sq. glass tiles – for sides
Assorted mosaic pieces:
  Stained glass pieces
  Glass tile pieces
  Ceramic tile pieces
  Mirror pieces
White sanded grout

### Heidi's Hint:

Purchase pre-broken and tumbled glass and ceramic tile pieces or cut tiles to the desired size and shape with wheeled tile nippers.

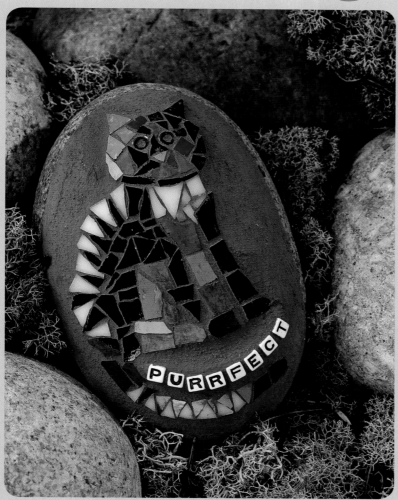

## MATERIALS FOR THE CAT ROCK

Basic Mosaic Supplies, page 11
Pattern, page 39
Smooth $4^1/_2$" x $6^1/_2$" oval river rock
Mosaic pieces:
    Stained glass pieces
      Two $^1/_4$" dia. yellow glass beads – for eyes
      Letter beads – PURRFECT
Painter's masking tape
Nutmeg Brown sanded grout

## MATERIALS FOR THE GECKO ROCK

Basic Mosaic Supplies, page 11
Pattern, page 43
Smooth 5" x 8" oval river rock
Mosaic pieces:
    Stained glass pieces
    $^1/_2$" sq. ceramic tiles
    Letter beads – DREAM A LITTLE DREAM
Painter's masking tape
Sahara Tan sanded grout

## SPECIAL INSTRUCTIONS

Use painter's tape to mask off the desired shape on each rock before grouting. For the cat, embed the eye beads in the grout with the holes showing.

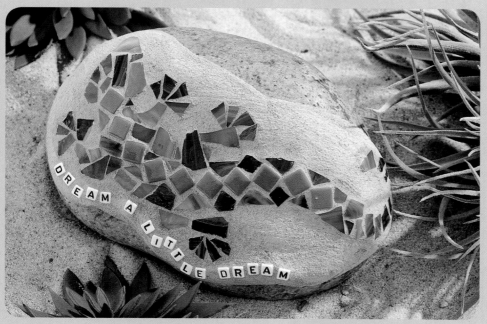

# Mosaic Rocks

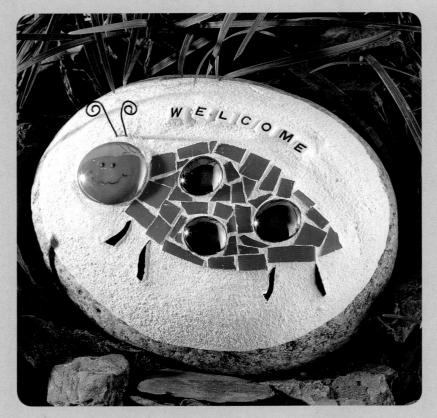

## MATERIALS FOR THE LADYBUG ROCK
Basic Mosaic Supplies, page 11
Pattern, page 42
Smooth 5" x 7" oval river rock
Mosaic pieces:
 Stained glass pieces
 Flat marbles
 Letter beads – WELCOME
Painter's masking tape
Fine-gauge black wire – two $1\frac{1}{2}$" lengths
Needle-nose pliers
Black fine-point permanent marker
Butter Cream sanded grout

## MATERIALS FOR THE RED HEART ROCK
Basic Mosaic Supplies, page 11
Pattern, page 42
Smooth 7" dia. river rock
Mosaic pieces:
 Stained glass pieces
 1" sq. ceramic tiles
 $\frac{1}{2}$" sq. ceramic tiles
 Glass shapes – heart and flower
Painter's masking tape
Metal flower charm – to be glued to the
 mosaic after cleanup
White sanded grout

## MATERIALS FOR THE PATRIOTIC HEART RO
Basic Mosaic Supplies, page 11
Pattern, page 43
Smooth $5\frac{1}{2}$" dia. river rock
Mosaic pieces:
 Stained glass pieces
 Ceramic star
Painter's masking tape
White sanded grout

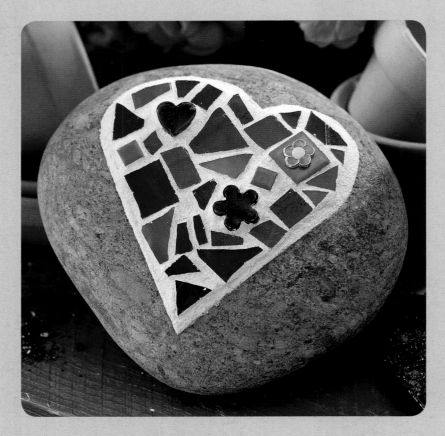

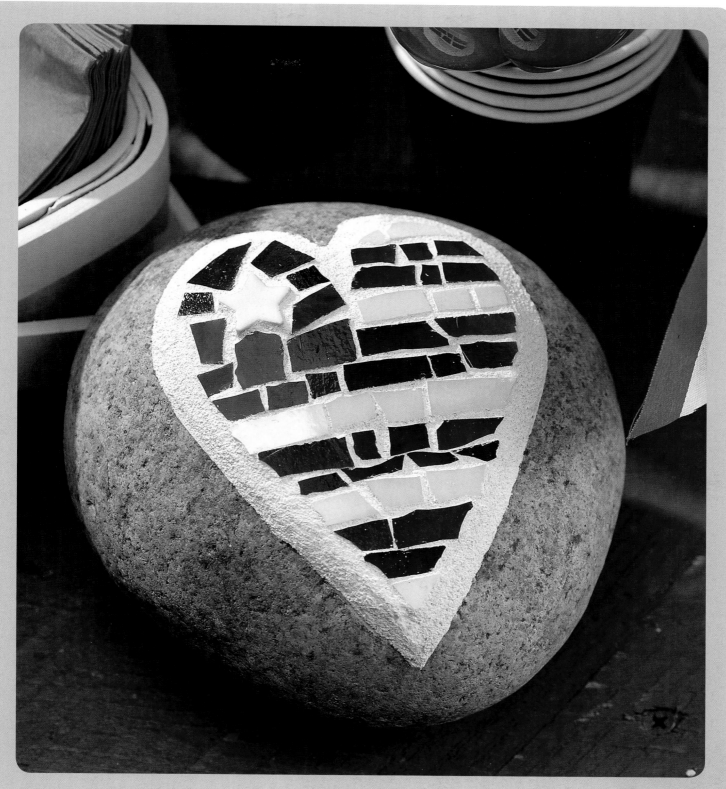

## SPECIAL INSTRUCTIONS

Use painter's tape to mask off the desired shape on each rock before grouting. For the Ladybug antennae, use the pliers to coil one end of each wire and insert the other end into the wet grout. Draw the eyes and mouth on the head.

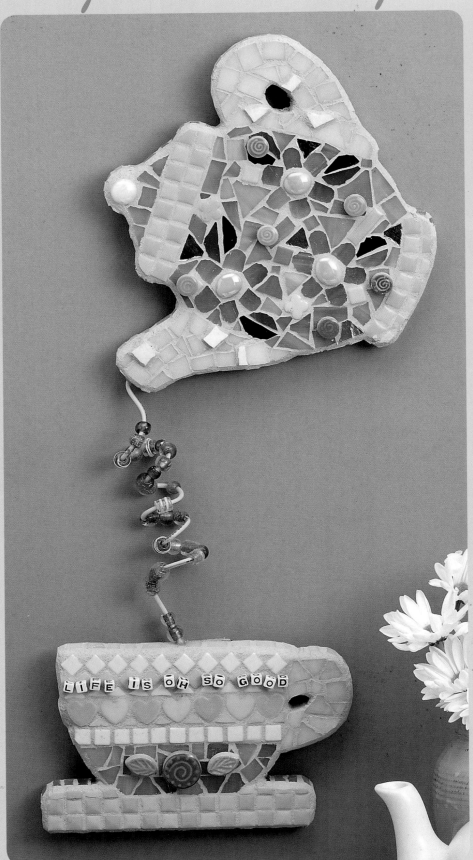

## MATERIALS

Basic Mosaic Supplies, page 11
$8^1/2$"h x 10"w MDF wood teapot
5"h x 8"w MDF wood teacup
Drill with $^1/8$" bit
Mosaic pieces:
> Ceramic shapes – hearts and
> 4-petal flowers
> Letter beads – LIFE IS OH
> SO GOOD
> Flat marbles – for flower centers
> and teapot lid

Assorted mosaic pieces:
> Stained glass pieces
> Smalti glass tiles – white
> Mirror pieces
> $^1/2$" sq. ceramic tiles

Ceramic shapes – round flowers and
> leaves to be glued to the
> mosaic after cleanup

Quartz sanded grout
16-gauge beige electrical wire –
> 3' length

1" dia. dowel
Glass beads – to fit on wire

## SPECIAL INSTRUCTIONS

Center and drill a hole in the side
edge of the teapot spout and the
top of the cup. Leaving the holes
uncovered, glue the mosaic pieces
to the pot and cup. Before grouting,
place a toothpick in each hole.
Let the grout set and remove the
toothpicks. Leaving $1^1/2$" on each end
straight, wrap the wire around the
dowel. Thread the beads on the wire
and glue the wire ends in the holes.

# Dancing Girl

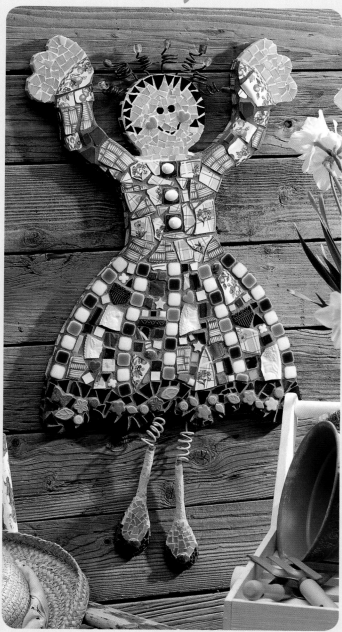

## MATERIALS

Basic Mosaic Supplies, page 11
16"w x 24"h MDF wood dancing girl
Drill with $1/8$" bit
Mosaic pieces for top:
    Stained glass pieces
    Broken plates/china – blue prints and white floral embossed
    Flat marbles
    1" sq. ceramic tiles
    Mirror pieces
    Ceramic tile pieces
    Ceramic shapes – hearts, leaves, flowers, circles, butterfly, stars, and geometrics
    $1/2$" sq. ceramic tiles
    $1^1/4$" sq. ceramic tiles
    Smalti glass tiles – assorted sizes and colors
Mosaic pieces for sides:
    Stained glass pieces – for hands, neck, hair, and bottom edge of dress
    Ceramic tiles/broken china – for sides of dress
Flat marbles – for buttons on dress, to be glued to the mosaic after cleanup
Two $6^3/4$" long wooden spoons
16-gauge electrical wire – two 18" beige lengths and seven 12" black lengths
1" dia. dowel
Glass beads – to fit on wire
Captain's Blue sanded grout – for dress and shoes
Butter Cream sanded grout – for face, hands, and legs

## SPECIAL INSTRUCTIONS

Drill 7 holes around the top of the head for the hair, 2 at the center bottom of the dress for the legs, and 1 in the end of each wooden spoon. Leaving the holes uncovered, glue the mosaic pieces to the girl. Before grouting, place a toothpick in each hole. Let the grout set and remove the toothpicks. Leaving $1^1/2$" on each end straight, coil each wire around the dowel. For the hair, glue one wire end in each hole; glue glass beads to the remaining end of each wire. For the legs, thread a bead on each wire and glue the wire ends in the dress and spoon holes.

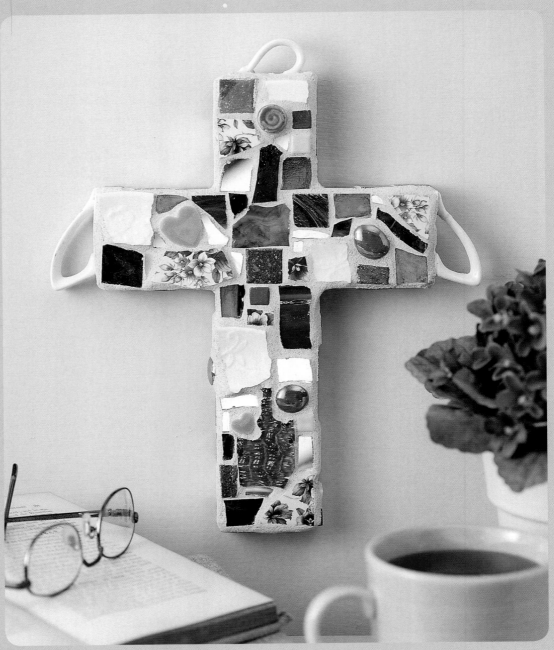

## MATERIALS

Basic Mosaic Supplies, page 11
7"w x 10"h MDF wood cross
Assorted mosaic pieces:
    Small flat marbles
    Stained glass pieces
    1" sq. glass tiles
    Mirror pieces
    $1/2$" sq. ceramic tiles

Vintage reproduction tiles – pansy print
Broken plates/china – white embossed floral and teacup handles
Ceramic hearts and round flower
Glass cutting tool
Butter Cream sanded grout

## SPECIAL INSTRUCTIONS

To cut out a teacup handle, score a rectangle in the cup around the handle with the glass cutting tool. Use the wheeled tile nippers to cut along the scored lines.

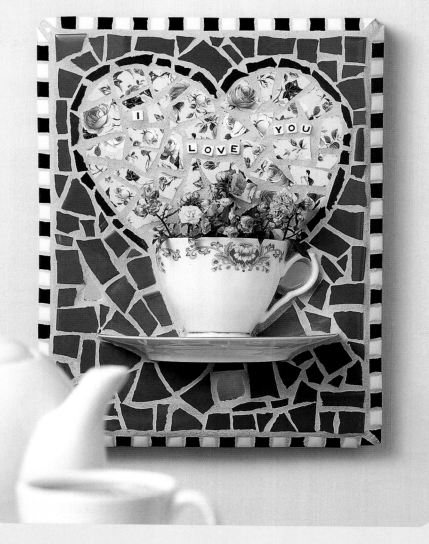

## Heidi's Hint:
It is a good idea to have backup china pieces to use in case the teacup or saucer breaks as it is being cut. Old china pieces may shatter due to fractures that can't be seen. If this happens, just use these pieces in the mosaic.

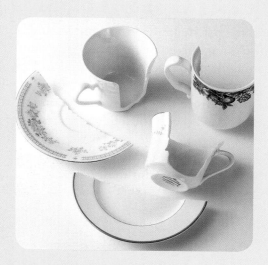

## MATERIALS
Basic Mosaic Supplies, page 11
Pattern, page 41
8¹/₂" x 11" wood base with beveled edges and attached hanger
Mosaic pieces:
    ¹/₂" sq. ceramic tiles – for sides
    ¹/₂" sq. ceramic tiles – cut into triangles for the corners
    China teacup and saucer
    Letter beads – I LOVE YOU
Assorted mosaic pieces:
    Ceramic tile pieces – floral and solid colors
    Mirror pieces
Glass cutting tool or small tile saw
Platinum Grey sanded grout

## SPECIAL INSTRUCTIONS
To cut the teacup and saucer, score each piece with the glass cutting tool. Use the wheeled tile nippers to cut along the scored line; then, use the nippers to even up any jagged edges. Glue the edges of the cup and saucer to the base and allow to dry before grouting.

## Heidi's Hint:
For the mosaic enthusiast, a small tile saw is a good investment, since it works very well for cutting cups, saucers, and other large pieces.

# Heidi's Faux Mosaic Technique

*Use dimensional paint instead of grout to create a mosaic look on glass. Use this technique to make the projects on pages 30 to 33. Always wear goggles when cutting mosaic pieces.*

**1** Trace the half pattern onto the paper side of self-adhesive laminate. Fold along the dashed line and cut on the solid lines around the design pattern and the background (to be used as a stencil).

**2** Choose mosaic pieces in the desired colors for the project. Use the materials listed with the individual projects, or feel free to substitute other types of tile, glass, or ceramic pieces.

**3** To determine placement, arrange the mosaic pieces on the design pattern, using wheeled tile nippers to cut the pieces as needed. Leave a small amount of space around each piece.

**4** Remove the paper backing from the background stencil and place the sticky side down on the canister lid or bottle front; adjust to center the stencil.

**5** Squeeze the dimensional paint onto the glass in the cut-out area of the stencil and spread it with the palette knife. (The paint should be thick enough to come up around the sides of the mosaic pieces as they are placed and act as a grout to bind them.) While wet, carefully lift the stencil from the glass; then, wearing gloves and beginning with the letter beads, transfer the mosaic pieces from your pattern onto the wet paint (use tweezers to pick up the small pieces). Allow the paint to dry.

**6** To adhere pieces to the top of the mosaic surface, place a small drop of dimensional paint on the back of the piece and press it in place. Allow the paint to dry.

**7** Tie novelty yarn around the neck of the canister or bottle. Dab glue on the ends and twist the ends until the glue dries. Thread beads onto the yarn; knot the ends.

## Heidi's Hints:

• Wheeled tile nippers make it easy to cut the desired shape from tiles, mirrors, stained glass, and china pieces.

• Size the design pattern on a photocopier and adjust the stencil border to fit any flat glass surface.

• Use this technique to create geometric, abstract, or floral stencils.

## FAUX MOSAIC SUPPLIES

*Lists of specific materials accompany individual project information. Many of the tools, mosaic pieces, and other materials listed are available through www.heidiborchers.com, at local craft or hardware stores, or online. Follow manufacturer's instructions to use each product.*

Clear, self-adhesive laminate
Mosaic pieces (ceramic and glass tiles, (mirrors, stained glass, china, and beads)
Goggles
Wheeled tile nippers
Delta Texture Magic™ Dimensional Paint™ (see project materials for color)
Palette knife
Disposable gloves
Tweezers
Novelty yarns
Weldbond® Universal Adhesive or a liquid fray preventative (used to prevent yarn ends from fraying)
Glass beads (see project materials)

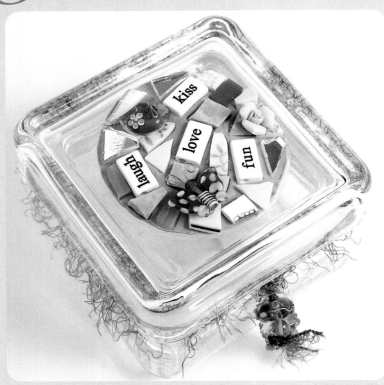

## MATERIALS FOR THE LOVE & LAUGH CANISTER

Faux Mosaic Supplies, page 29
Pattern, page 44
Glass canister with a 4" x 4" flat lid
Delta Texture Magic™ Dimensional
    Paint™ – Deep Lilac
Mosaic pieces:
    Word beads – LAUGH, LOVE, FUN, KISS
Assorted mosaic pieces:
    Stained glass pieces
    Mirror pieces
    Broken plates
1/2" dia. porcelain rose – to be
    adhered to the mosaic surface
Needle-nose pliers
26-gauge gold wire – two 1" lengths
Butterfly and heart glass beads – to be adhered
    to the mosaic surface
Assorted round beads – to thread onto yarn
Novelty yarn – 1 yard

## SPECIAL INSTRUCTIONS

For butterfly antennae, use the pliers to coil one end of each wire,
dab glue on the other end, and insert it in the top of the bead.

## MATERIALS FOR THE MOTHER CANISTER

Faux Mosaic Supplies, page 29
Pattern, page 44
Glass canister with a 4" x 4" flat lid
Delta Texture Magic™ Dimensional Paint™ – Blue
    Whisper
Mosaic pieces:
    Letter beads – MOTHER
    Glass heart bead
Assorted mosaic pieces:
    Stained glass pieces
    Mirror pieces
    Broken plates/china
Needle-nose pliers
26-gauge gold wire – two 1" lengths
Butterfly bead – to be adhered to the mosaic surface
Assorted round beads – to thread onto yarn
Novelty yarn – 1 yard

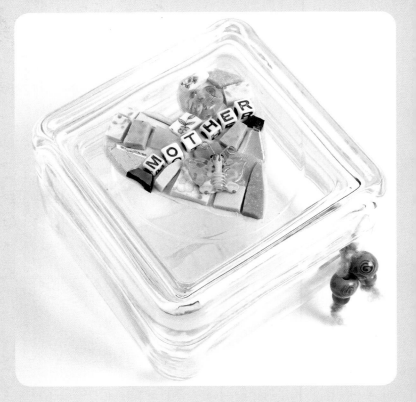

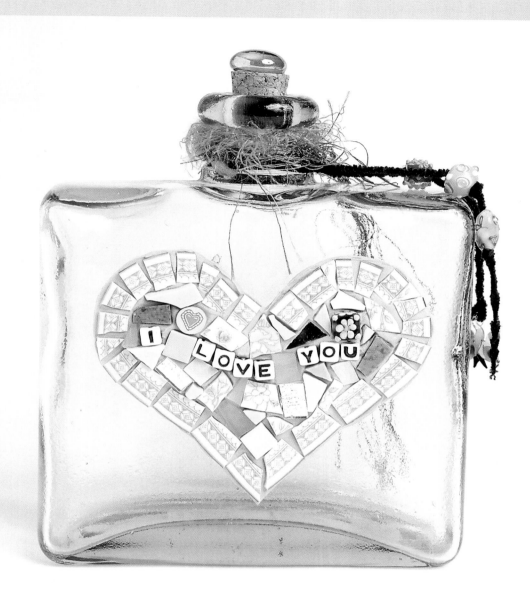

## MATERIALS FOR THE I LOVE YOU BOTTLE

Faux Mosaic Supplies, page 29
Pattern, page 44
Glass bottle with a 5$\frac{1}{2}$"h x 6"w flat front
Delta Texture Magic™ Dimensional
    Paint™ – Rose Whisper
Mosaic pieces:
    Letter beads – I LOVE YOU
    Broken plate – including pieces with
      a border design

Assorted mosaic pieces:
    Stained glass pieces
    Mirror pieces
    $\frac{1}{2}$" sq. ceramic tiles
    Glass and clay beads
Assorted beads – to thread onto yarn
Novelty yarns – assorted 18" lengths

# Glass Containers

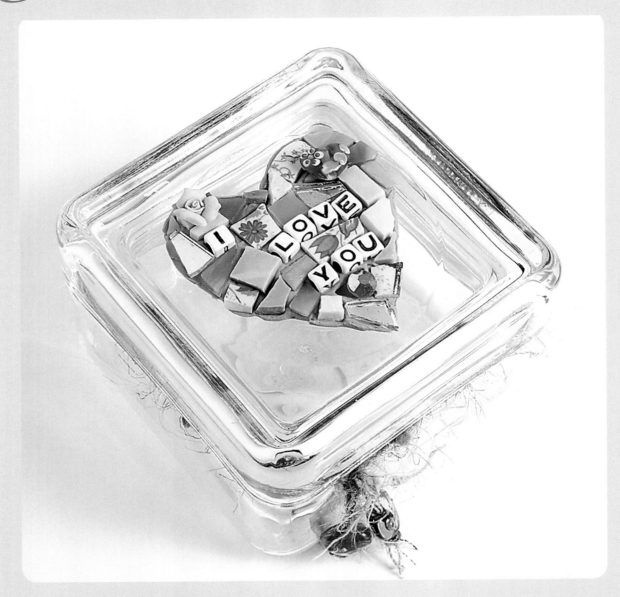

## MATERIALS FOR THE I LOVE YOU CANISTER

Faux Mosaic Supplies, page 29
Pattern, page 44
Glass canister with a 4" x 4" flat lid
Delta Texture Magic™ Dimensional Paint™ – Deep Lilac
Mosaic pieces:
    Letter beads – I LOVE YOU
Assorted mosaic pieces:
    Stained glass pieces
    Mirror pieces
    Broken plates/china

Rhinestone – to be adhered to the mosaic surface
1/2" dia. porcelain rose – to be adhered to the mosaic surface
Glass heart beads – to be adhered to the mosaic surface and threaded onto yarn
Novelty yarn – 1 yard

*Heidi's Hint:*
The porcelain roses used in these projects were broken from a bouquet that came from a discount store.

## MATERIALS FOR THE LOVE CANISTER

Faux Mosaic Supplies, page 29
Pattern, page 44
Glass canister with a 4" x 4" flat lid
Delta Texture Magic™ Dimensional Paint™
  – Almond
Mosaic pieces:
    Letter beads – LOVE
Assorted mosaic pieces:
    Stained glass pieces
    Broken plates/china
    1/2" sq. ceramic tiles
    Mirror pieces

Ladybug bead – to be adhered to the
    mosaic surface
1/2" dia. porcelain rose – to be adhered to
    the mosaic surface
Assorted round beads – to thread onto yarn
Novelty yarn – 1 yard

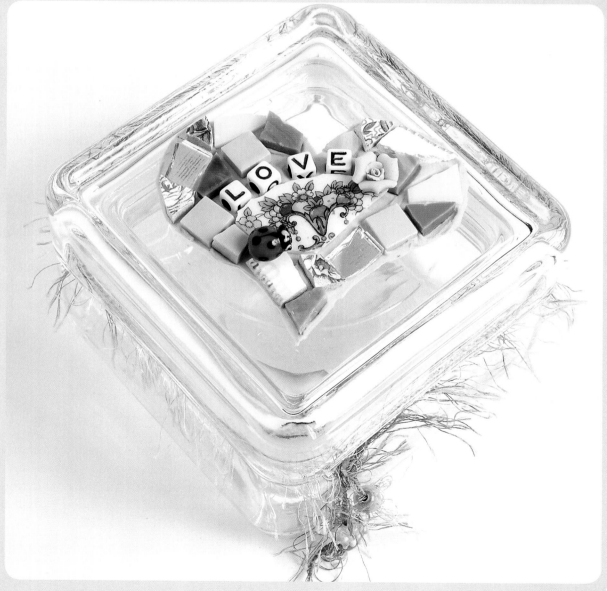

# Heidi's Collage & Mosaic Technique

*Pair paper collage with mosaic pieces for a striking combo. Use this technique to make the projects on pages 36 to 38. Always wear goggles when cutting mosaic pieces.*

**1** Cover the work area with wax paper.

**2** Tear the collage paper pieces to fit as you work. Wearing gloves, brush a coat of Weldbond® Final Coat onto the back of the canvas, then on the back of the collage pieces. Overlapping the pieces, glue the paper to the canvas. Brush Final Coat on the top of the paper. Press out any air bubbles. Cover the entire canvas, including the sides. Allow to air dry or use the hair dryer on low.

**3** Cover the work area with several layers of kraft paper.

**4** Choose mosaic pieces in the desired colors for the project. Use the materials listed with the individual projects, or feel free to substitute other types of tile, glass, or ceramic pieces. These projects call for Smalti tiles (hand-cut opaque glass tiles that vary in color and shape), but other glass tiles may be used in their place.

**5** Refer to the project photo and arrange the mosaic pieces on the wooden spoons or the wood frame of the canvas, using wheeled tile nippers to cut pieces as needed. Follow Arranging Mosaic Pieces, page 9, to leave space around each piece for the grout unless otherwise noted.

**6** When all the pieces are in place, pick up one at a time (use tweezers to pick up small pieces), place a small drop of Weldbond® Universal Adhesive on the back of the piece, and glue it to the wooden spoon or frame. Mosaic the inner edges of the frame as desired. Allow the glue to dry (about one hour).

## Heidi's Hints:

- Wheeled tile nippers make it easy to cut the desired shape from tiles, mirrors, stained glass, and china pieces.

- For additional bonding and waterproofing when mixing grout, Weldbond® Universal Adhesive may be added to the water, using 2 parts glue and 1 part water. Stir the mixture into the dry grout, adding more water as needed to achieve a paste-like consistency.

- Use caution if you smooth the grout with your fingers; the cut edges of the mosaic pieces can cut through disposable gloves.

**7** Use painter's tape to mask off the collaged area of the Canvas Shadow Box just before grouting. (Artful Annie doesn't require masking.) Wearing gloves, pour grout into a plastic container. Slowly add water and mix thoroughly with a craft stick to form a thick, smooth paste; then, use the stick and work quickly to apply the grout between the mosaic pieces, filling in the spaces.

**8** When the project is grouted, begin at the top and wipe a slightly damp sponge over a small area, just uncovering the mosaic pieces and smoothing out the grout. Don't wipe the pieces too much, but leave a grout haze on them. Carefully remove the masking tape from the collaged area of the Canvas Shadow Box (if any paper comes off, you can reapply after the mosaic is complete).

**9** Allow the haze to air dry or use the hairdryer on low for several minutes until the haze is dry and looks chalky. Being careful to avoid the wet grout between the pieces, use a dry paper towel to clean each mosaic piece separately. Use a cotton swab for any detailed cleaning. Let the grout dry overnight. Use vinegar on a swab or paper towel to remove any remaining haze.

## COLLAGE & MOSAIC SUPPLIES

*Lists of specific materials accompany individual project information. Many of the tools, mosaic pieces, and other materials listed are available through www.heidiborchers.com, at local craft or hardware stores, or online. Follow manufacturer's instructions to use each product.*

Stretched canvas (see project materials for size and shape)
Wax paper
Colorful collage/scrapbooking papers
Disposable gloves
1"w foam brush
Weldbond® Final Coat (used as collage glue)
Hairdryer (optional)
Kraft paper
Mosaic pieces (ceramic and glass tiles, mirrors, stained glass, beads, ceramic shapes)
Goggles
Wheeled tile nippers
Tweezers
Weldbond® Universal Adhesive (used to attach mosaic pieces and may be used as a grout additive/bonding agent)
Sanded grout (see project materials for color)
Plastic containers
Craft stick or 1$^1$/$_2$" plastic putty knife to apply grout
Household sponge
Paper towels
Cotton swabs
White vinegar

# Artful Annie

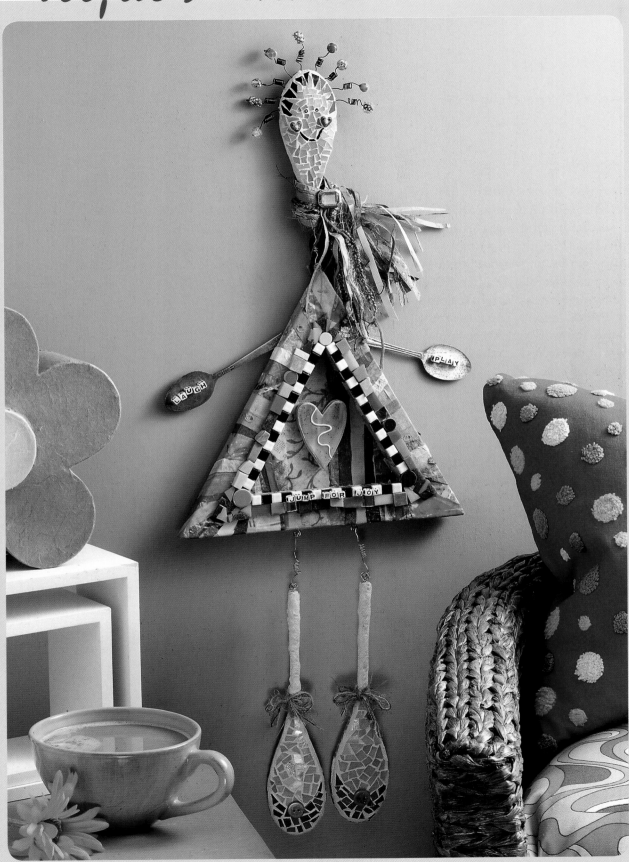

## MATERIALS

Collage & Mosaic Supplies, page 35
Drill with $^1/_{16}$" bit
Wooden spoons – two 10" long for the legs and one
 6" long for the head
6 small silver screw eyes ($^5/_8$" long)
Two silver spoons – flattened with a hammer
12" triangular stretched canvas on wood frame – the
 canvas back is used as the front of the mosaic
Hammer and four $^1/_2$" long nails – to attach silver spoons
 to canvas
Mosaic pieces:
 Stained glass pieces – for face, hair, mouth, feet,
  and shoes
 $^1/_4$" dia. glass beads – for eyes
 Heart beads – for cheeks
Toothpicks
Butter Cream sanded grout
Assorted mosaic pieces:
 $^1/_2$" ceramic tiles
 Mirror pieces
 Ceramic shapes – circles
 Smalti glass tiles – assorted colors
Decorative ceramic tile – heart shape
Letter beads – JUMP FOR JOY, LAUGH, and PLAY
 to be glued to the mosaic and spoons
22-gauge black wire – nine 8" lengths for hair
Glass beads – to fit on wire
20-gauge silver wire – three 10" lengths
Needle-nose pliers
Two $^1/_2$" dia. buttons
Novelty yarns
Scrapbooking papers – $^1/_4$"w strips for scarf
1" sq. rhinestone button

*Heidi's Hint:*
To grout the wooden spoon handles,
apply grout with the craft stick and
smooth it with gloved fingers.

## SPECIAL INSTRUCTIONS

Drill 1 hole in the end of each wooden spoon handle
and insert a screw eye. Drill 9 holes around the top of
the head spoon. Drill 2 holes $^1/_4$" apart near the end of
each silver spoon handle.

Apply the collage to the canvas and wood frame. Drill
2 holes $2^1/_2$" apart in the center of the bottom edge of
the canvas and 1 hole in the top point of the canvas.
Insert screw eyes into the holes. With the flat side of the
canvas up, measure 3" from the top point of the canvas
and mark $^1/_2$" from each side edge. Nail the back of
a silver spoon handle at each mark. Angle each spoon
as desired and secure with the second nail. Turn the
canvas over.

Leaving the drilled holes uncovered, glue mosaic
pieces to the wooden spoons. Before grouting, insert a
toothpick into each hole in the head spoon. Grout the
tiled areas and apply a thin layer of grout to the handles.
Let the grout set and remove the toothpicks.

Glue assorted mosaic pieces close together on the inner
edge of the collaged frame (these will not be grouted).
Glue the decorative heart tile at the center of the canvas.
Glue letter beads to the mosaic and silver spoons.

Leaving $^1/_2$" on each end straight, coil each black wire
around a pencil. Glue one wire end in each hole on the
head spoon; glue a glass bead on the remaining end.

Leaving $1^1/_2$" on each end straight, coil each silver wire
around a pencil. Use the pliers to wrap one end of each
wire several times through one screw eye on the canvas.
Wrap the opposite end of each wire through a screw eye
on the end of a wooden spoon.

Glue the $^1/_2$" dia. buttons to the shoes. Tie yarn bows
around the ankles. Wrap a yarn and paper strip scarf
around the neck; glue the pieces together where they
cross each other. Glue the rhinestone button to the scarf.

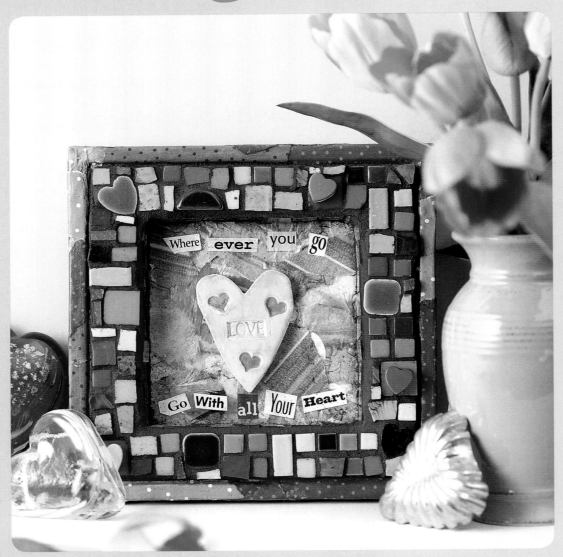

Collage & Mosaic Supplies, page 35

## Heidi's Hint:

Purchase an imprinted ceramic tile or make your own with polymer clay, a knife or cookie cutter, and rubber stamps.

**MATERIALS**

Collage & Mosaic Supplies, page 35
8" x 8" x 1" stretched canvas on wood frame
   – the canvas back is used as the front of
   the mosaic
Mosaic pieces:
   Ceramic shapes – half circle and hearts
   Mirror pieces – for inner edge of frame
Assorted mosaic pieces:
   $1/2$" sq. ceramic tiles
   1" sq. ceramic tiles
   Smalti glass tiles – assorted colors
Ceramic hearts – to be glued to the mosaic
   after cleanup
Painter's masking tape

Black Cherry sanded grout
Imprinted ceramic tile – imprinted with
   hearts and LOVE rubber stamp
Words cut from magazines

**SPECIAL INSTRUCTIONS**

After the masking tape has been removed from the collage area, glue the imprinted ceramic heart tile to the center of the collage with Weldbond® Universal Adhesive. Apply the word cutouts to the collage with Weldbond® Final Coat.

Rose Tile

Star Tile

Heart Tile

Cat Rock

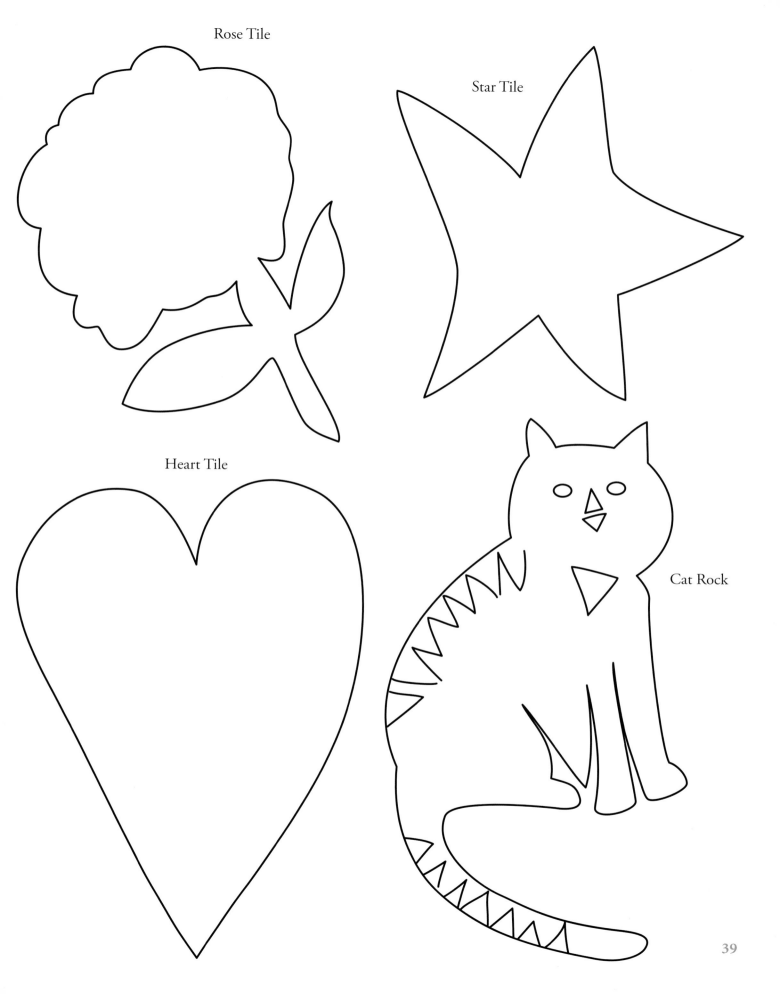

Sunburst Plaque

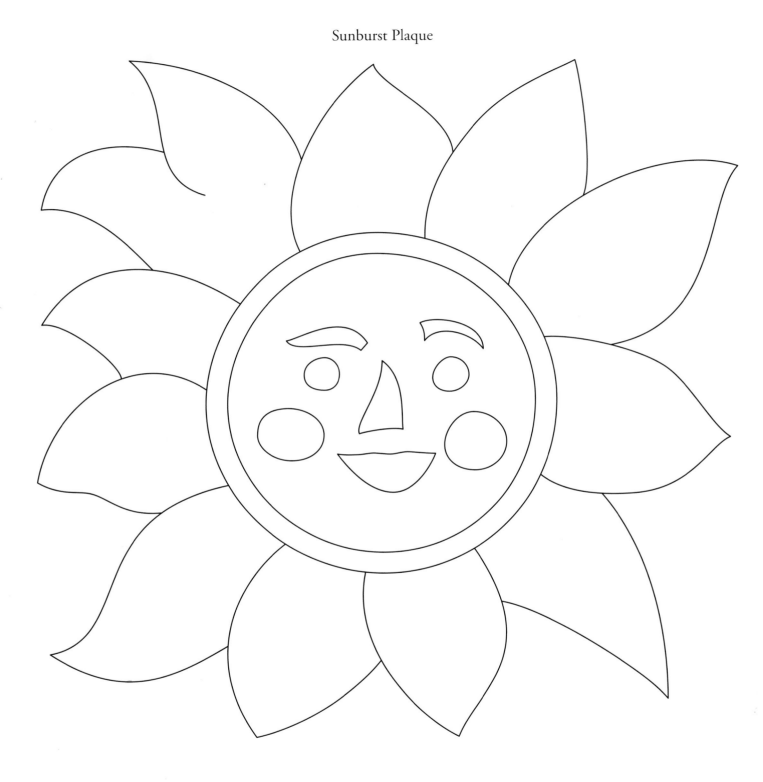

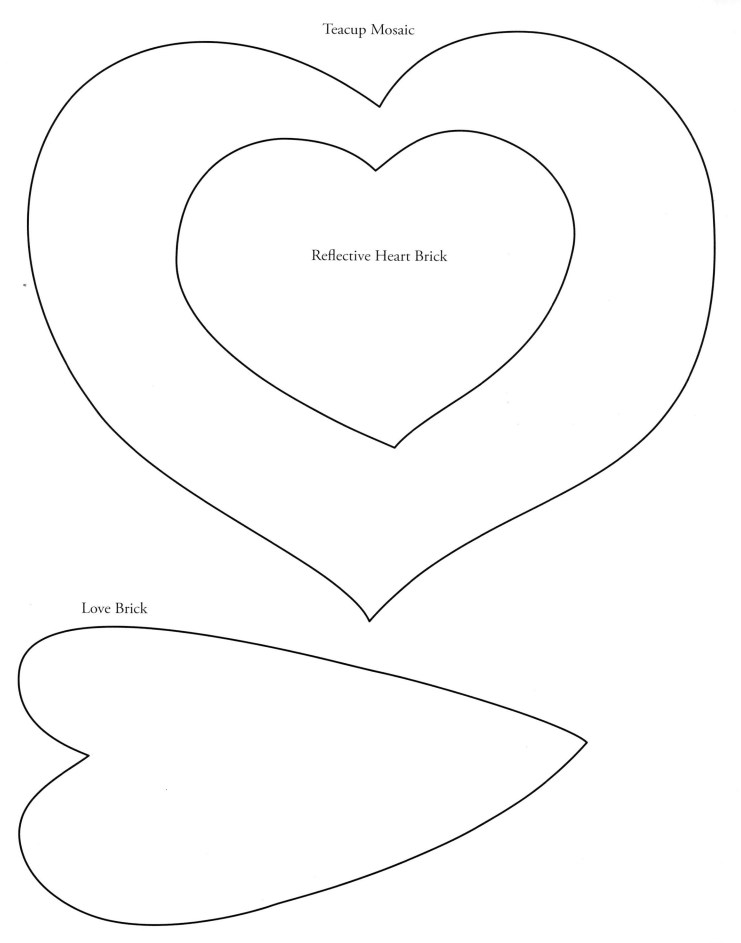

Reflective Heart Brick

Love Brick

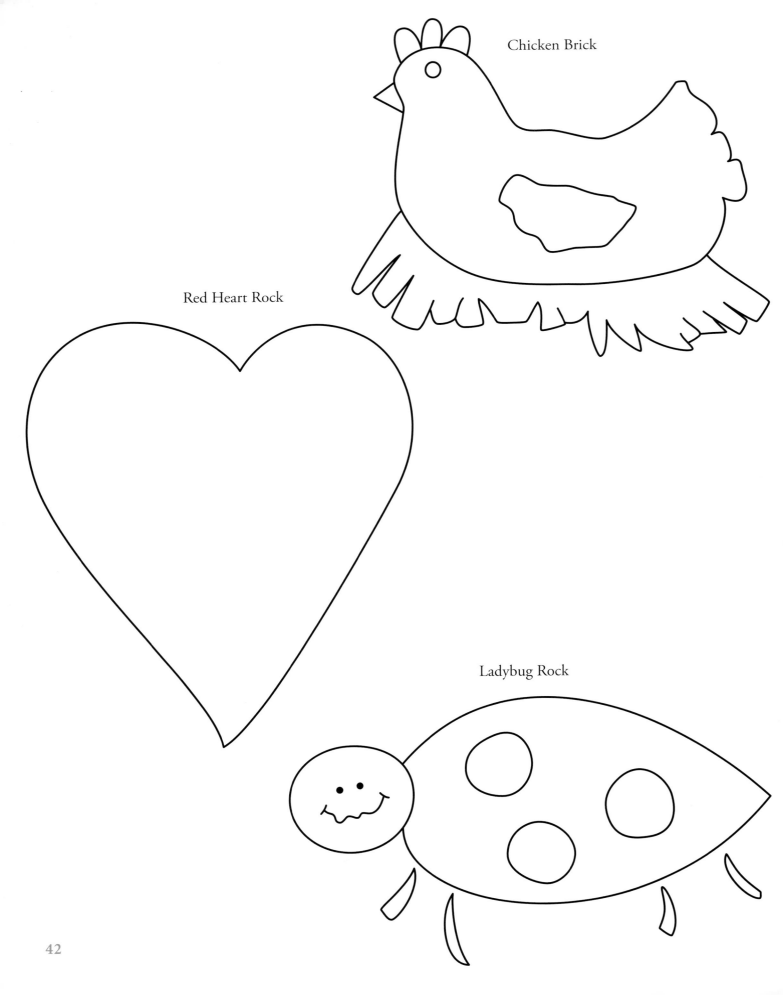

Chicken Brick

Red Heart Rock

Ladybug Rock

42

Patriotic Heart Rock

Gecko Rock

Cat Brick

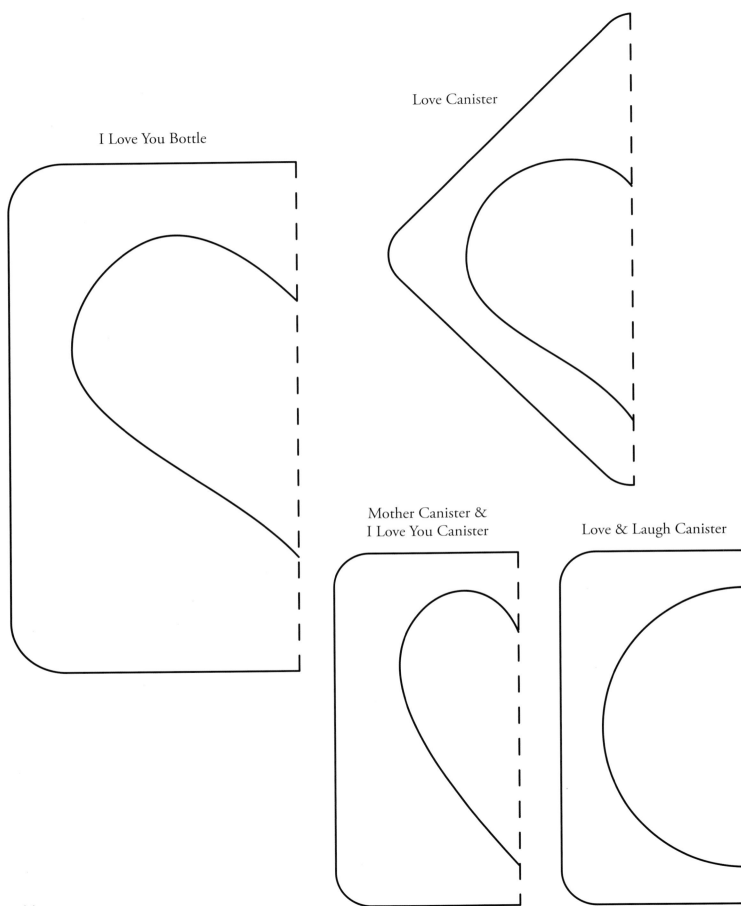

I Love You Bottle

Love Canister

Mother Canister &
I Love You Canister

Love & Laugh Canister